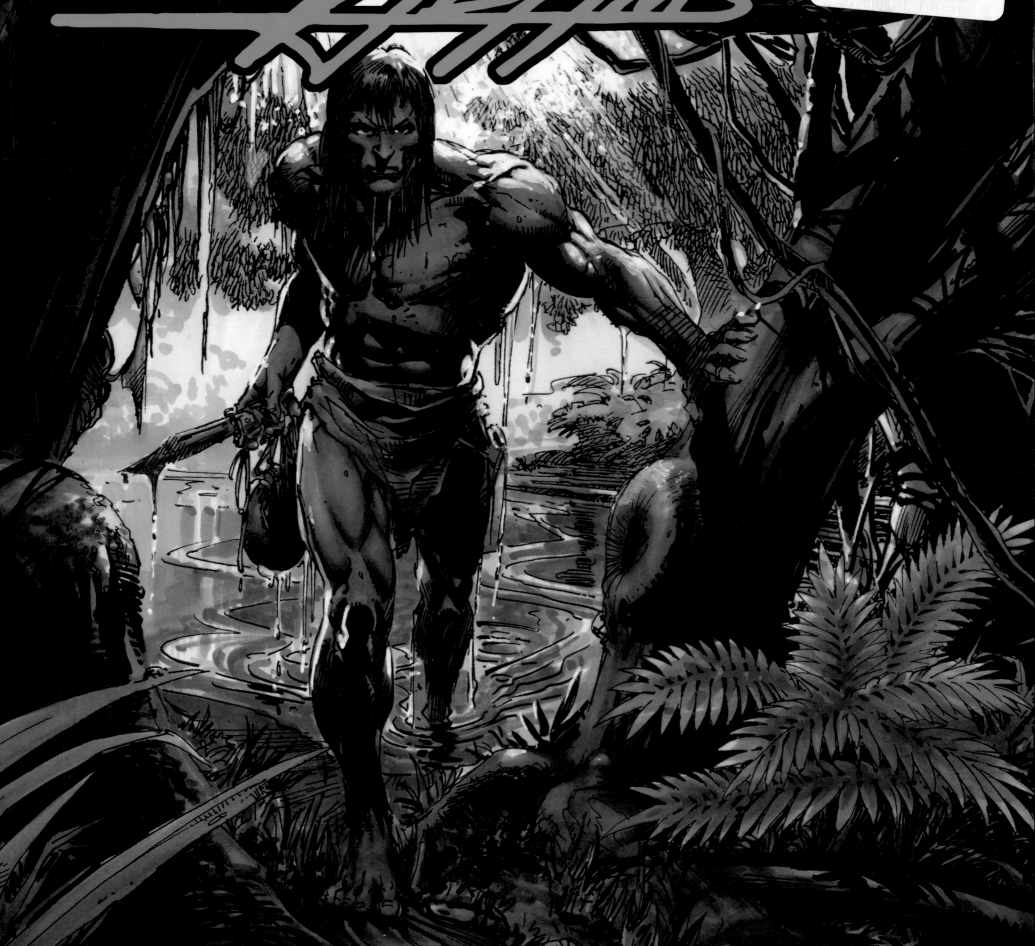

THE ART OF NEAL ADAMS

2007 CALENDAR-PORTFOLIO

Neal Adams

Vanguard Productions is pleased to present the first-ever calendar devoted to legendary Batman, X-Men, Green Lantern, Deadman comic book and Tarzan paperback book-cover artist, Neal Adams.

About himself influential Adams said, "Neal Adams is certainly not a fine artist, Neal Adams is a commercial artist, a cartoonist, and of course, a comic book artist. I hope in the end I am a skilled, drawing artist who can basically do anything that I am asked to do... or want to do."

Adams' comic-book work serves as a benchmark and inspiration for every illustrator who works in the field to this day. His topflight contributions to Marvel and DC Comics continued steadily through the mid-1970s when the artist felt it the time for expansion. Coinciding with the launch of his Continuity Studios, Adams augmented his comics work with cutting-edge advertising work, theatrical costume & stage design, amusement park ride design, magazine illustration and paperback book covers. Known primarily for his pen & ink work, the artist's legions of fans rarely get to see Adams' paintings. Showcased in this fourteen-month calendar is a unique selection of Neal's seldom-seen fully-rendered, color works. Some, are being published here for the first time anywhere.

Other Neal Adams projects available from Vanguard Productions:
Neal Adams Monsters • Neal Adams:The Sketch Book • The Complete Valeria The She-Bat

DECEMBER 2006

Sunday	Monday	Tuesday	Wednesday	Thursday	Friday	Saturday
						1
2	3	4	5	6	7	8
9	10	11	12	13	14	15
16	17	18	19	20	21	22
23	24	25	26	27	28	29
30	31					

JANUARY 2008

Sunday	Monday	Tuesday	Wednesday	Thursday	Friday	Saturday
		1	2	3	4	5
6	7	8	9	10	11	12
13	14	15	16	17	18	19
20	21	22	23	24	25	26
27	28	29	30	31		

Published by Vanguard Productions. Office of publication 390 Campus Drive Somerset, NJ 08873.
Artwork © 2007 Neal Adams. Trademarks and/or other copyrighted art,
if any, appear as historic examples of Neal Adams art. Editorial work / collective work © 2007 Vanguard Productions.
Art Director: J. David Spurlock. Production assistance by Dean Motter, Jason Adams
Special Thanks to everyone at Continuity Studios.
www.creativemix.com/vanguard • www.nealadams.com • Printed in China

VANGUARD PRODUCTIONS

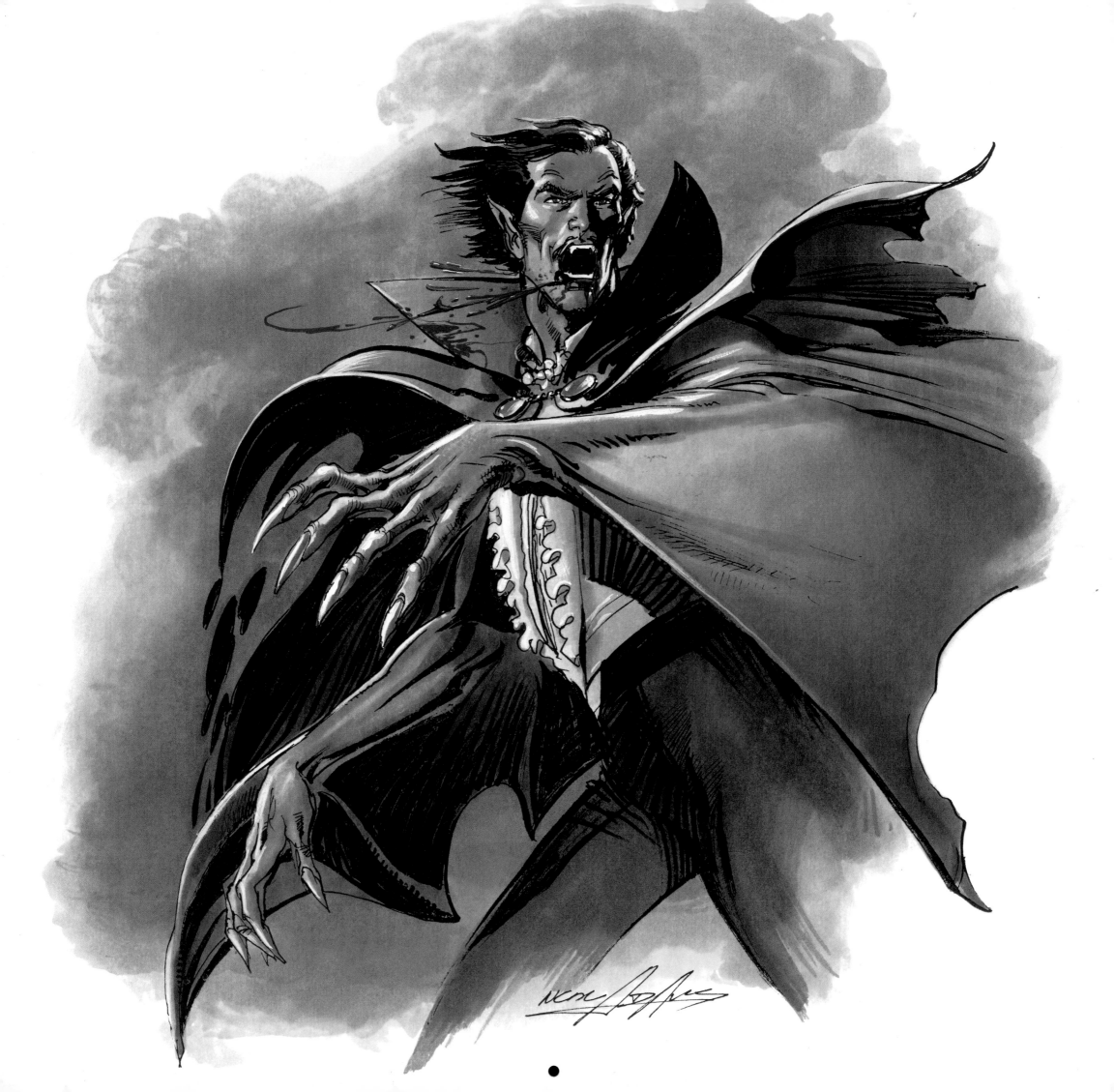

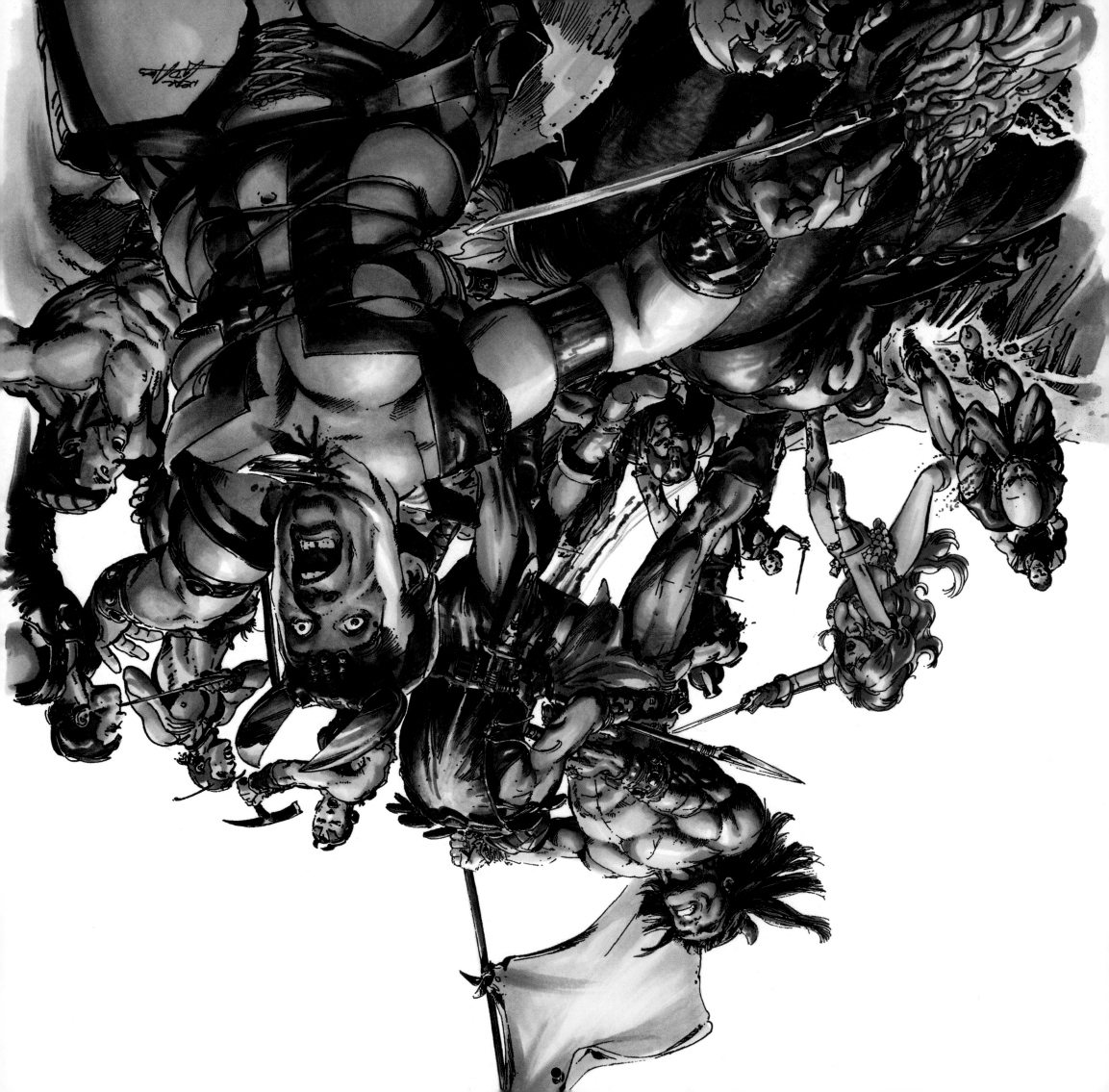

JANUARY

SUNDAY	MONDAY	TUESDAY	WEDNESDAY	THURSDAY	FRIDAY	SATURDAY
	1 NEW YEAR'S DAY	2	3	4	5	6
7	8	9	10	11	12	13
14	15 MARTIN LUTHER KING DAY	16	17	18	19	20
21	22	23	24	25	26	27
28	29	30	31			

FEBRUARY

				1	2	3
4	5	6	7	8	9	10
11	12	13	14	15	16	17
18	19	20	21	22	23	24
25	26	27	28			

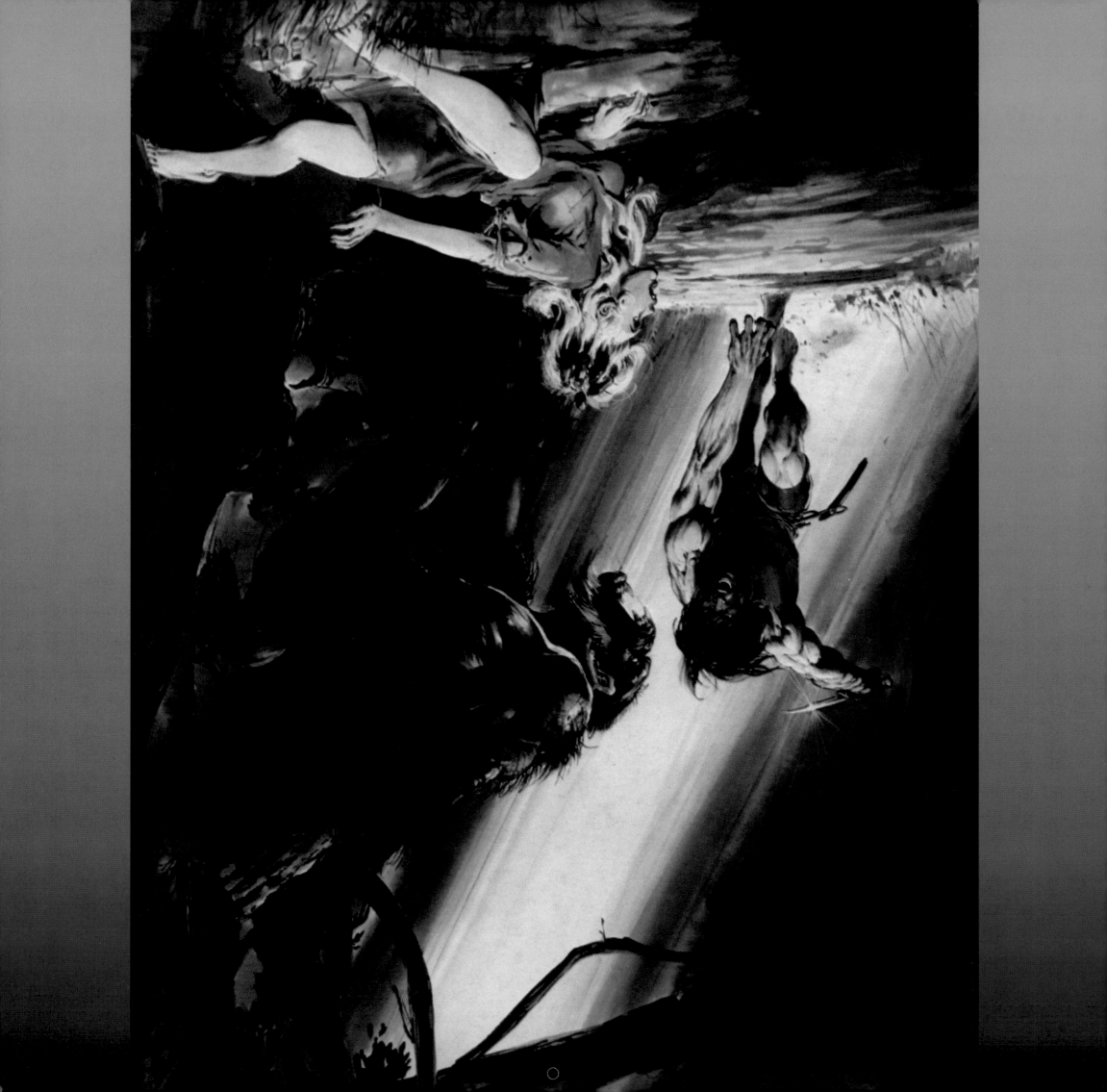

F E B R U A R Y

SUNDAY	MONDAY	TUESDAY	WEDNESDAY	THURSDAY	FRIDAY	SATURDAY
		JANUARY 1 2 3 4 5 6 7 8 9 10 11 12 13 14 15 16 17 18 19 20 21 22 23 24 25 26 27 28 29 30 31		**1**	**2**	**3** GROUNDHOG DAY
4	**5**	**6**	**7**	**8**	**9**	**10**
11	**12**	**13**	**14** VALENTINE'S DAY	**15**	**16**	**17**
18 CHINESE NEW YEAR YEAR OF THE PIG	**19** PRESIDENTS' DAY	**20**	**21**	**22**	**23**	**24**
25	**26**	**27**	**28** 	**MARCH** 1 2 3 4 5 6 7 8 9 10 11 12 13 14 15 16 17 18 19 20 21 22 23 24 25 26 27 28 29 30 31		

●

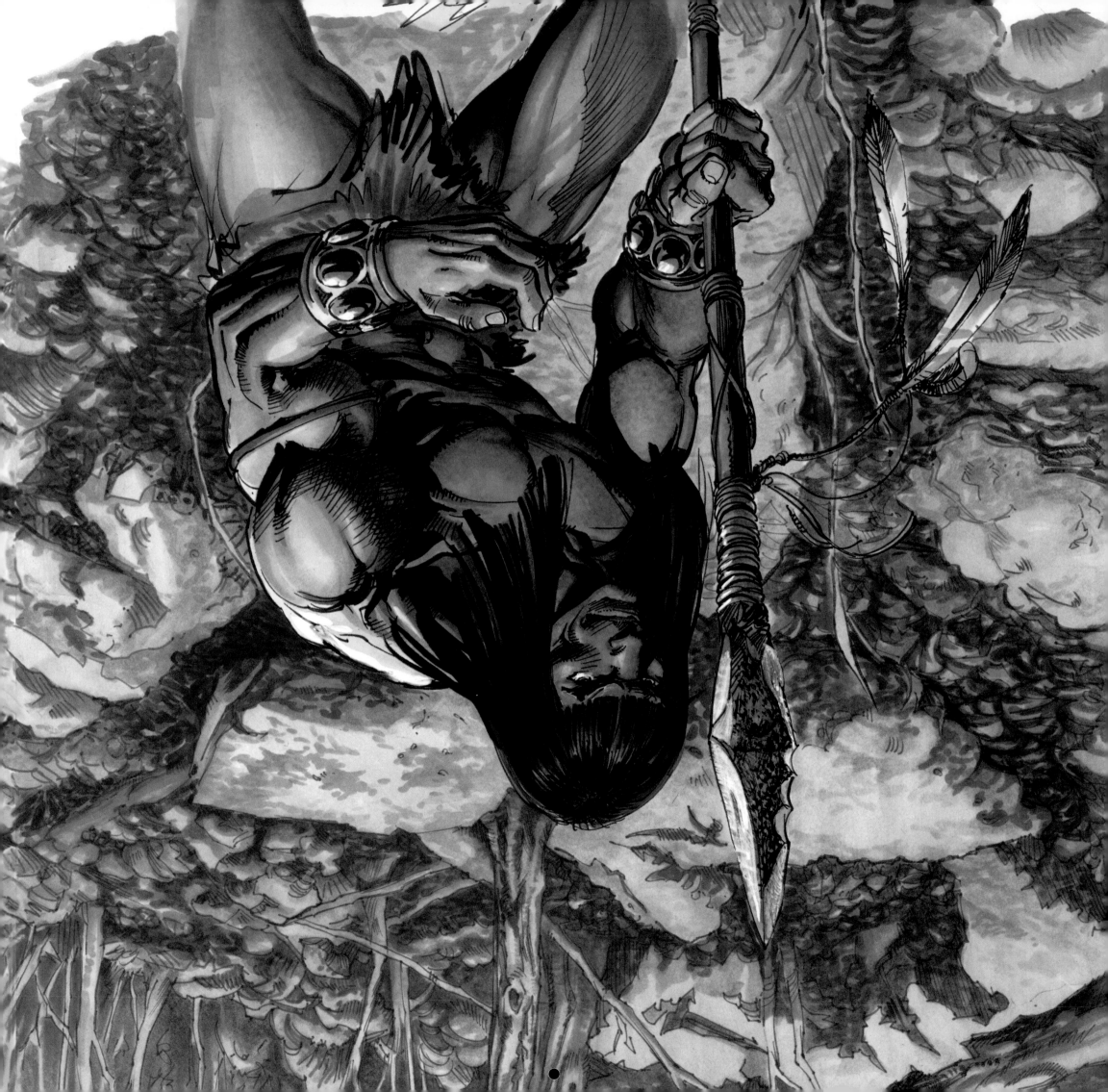

MARCH

SUNDAY	MONDAY	TUESDAY	WEDNESDAY	THURSDAY	FRIDAY	SATURDAY
FEBRUARY 　　　　1　2　3 4　5　6　7　8　9　10 11　12　13　14　15　16　17 18　19　20　21　22　23　24 25　26　27　28	**APRIL** 1　2　3　4　5　6　7 8　9　10　11　12　13　14 15　16　17　18　19　20　21 22　23　24　25　26　27　28 29　30			**1**	**2**	**3**
4	**5**	**6**	**7**	**8**	**9**	**10**
11	**12**	**13**	**14**	**15**	**16**	**17** ST. PATRICK'S DAY
18	**19**	**20**	**21**	**22**	**23**	**24**
25	**26**	**27**	**28**	**29**	**30**	**31**

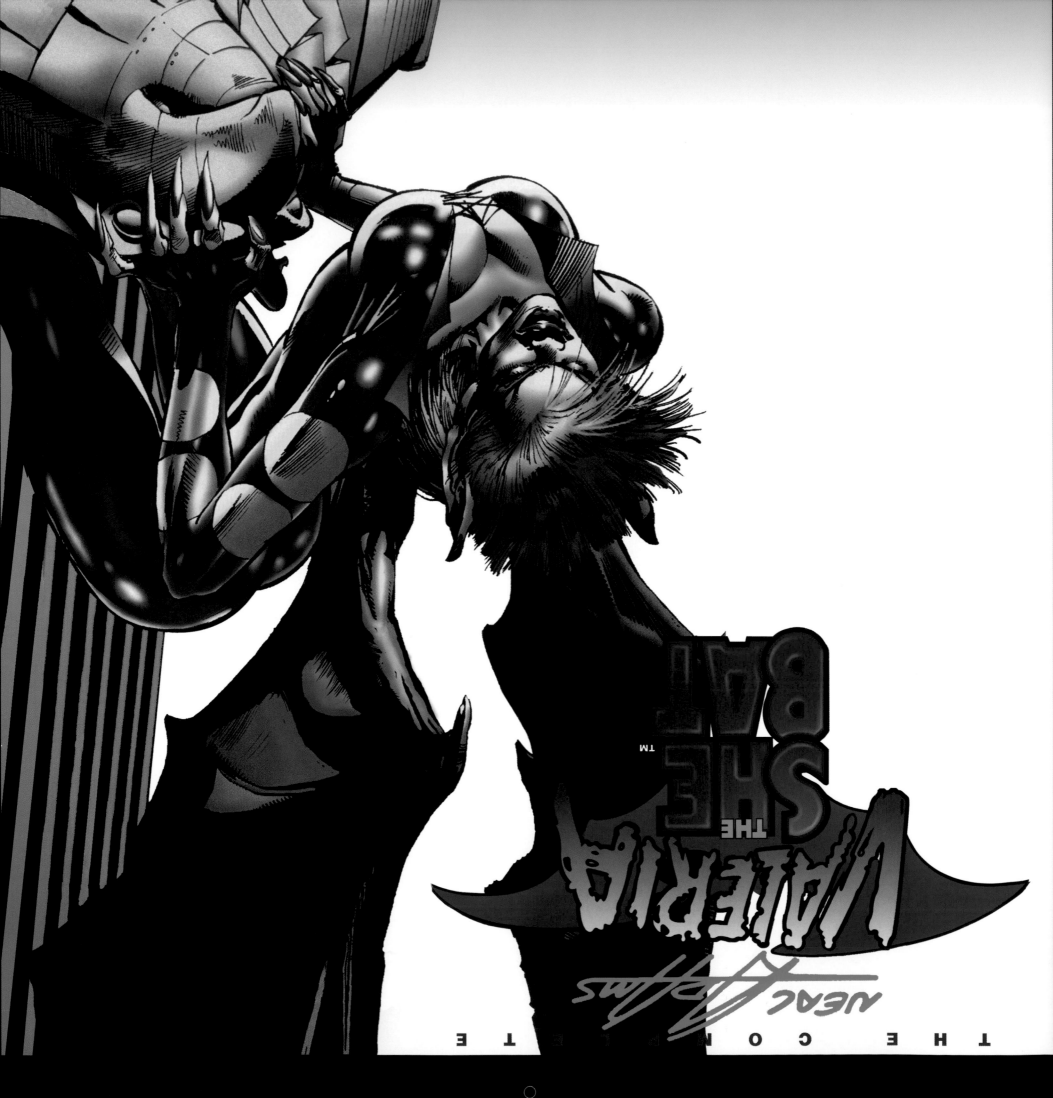

APRIL

SUNDAY	MONDAY	TUESDAY	WEDNESDAY	THURSDAY	FRIDAY	SATURDAY
1 APRIL FOOL'S	2	3 PASSOVER BEGINS	4	5	6 GOOD FRIDAY	7
8 EASTER	9	10	11	12	13	14
15	16	17	18	19	20	21
22	23	24	25	26	27	28
29	30					

FEBRUARY

			1	2	3	
4	5	6	7	8	9	10
11	12	13	14	15	16	17
18	19	20	21	22	23	24
25	26	27	28	29	30	31

MAY

	1	2	3	4	5	
6	7	8	9	10	11	12
13	14	15	16	17	18	19
20	21	22	23	24	25	26
27	28	29	30	31		

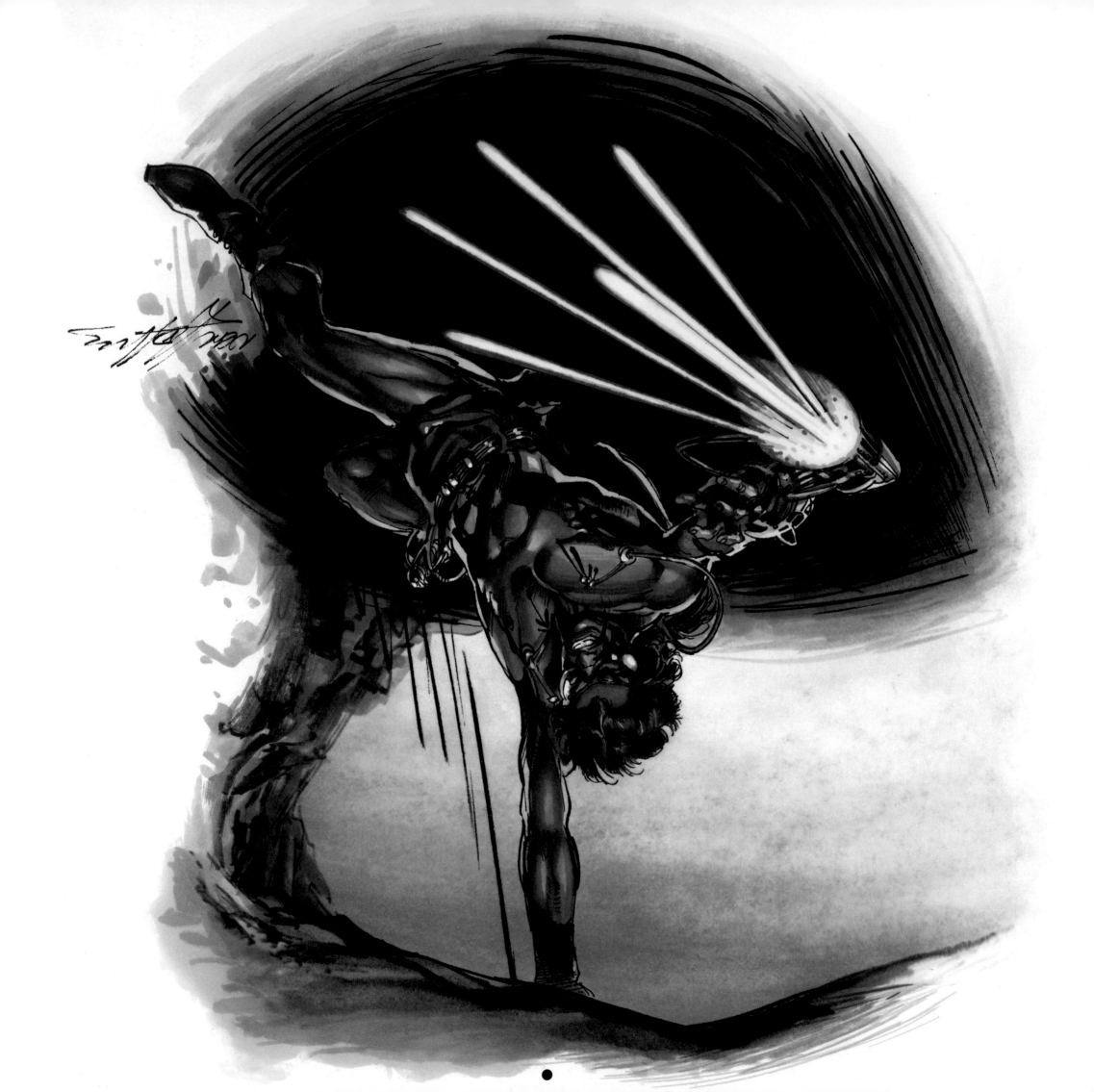

M A Y

SUNDAY	MONDAY	TUESDAY	WEDNESDAY	THURSDAY	FRIDAY	SATURDAY
APRIL 1 2 3 4 5 6 7 8 9 10 11 12 13 14 15 16 17 18 19 20 21 22 23 24 25 26 27 28 29 30		**1**	**2**	**3**	**4**	**5** BUDDHA'S BIRTHDAY CINCO DE MAYO
6	**7**	**8**	**9**	**10**	**11**	**12**
13 MOTHERS DAY	**14**	**15**	**16**	**17**	**18**	**19**
20	**21**	**22**	**23**	**24**	**25**	**26**
27	**28** MEMORIAL DAY	**29**	**30**	**31**	**JUNE** 3 4 5 6 7 8 9 10 11 12 13 14 15 16 17 18 19 20 21 22 23 24 25 26 27 28 29 30	1 2

●

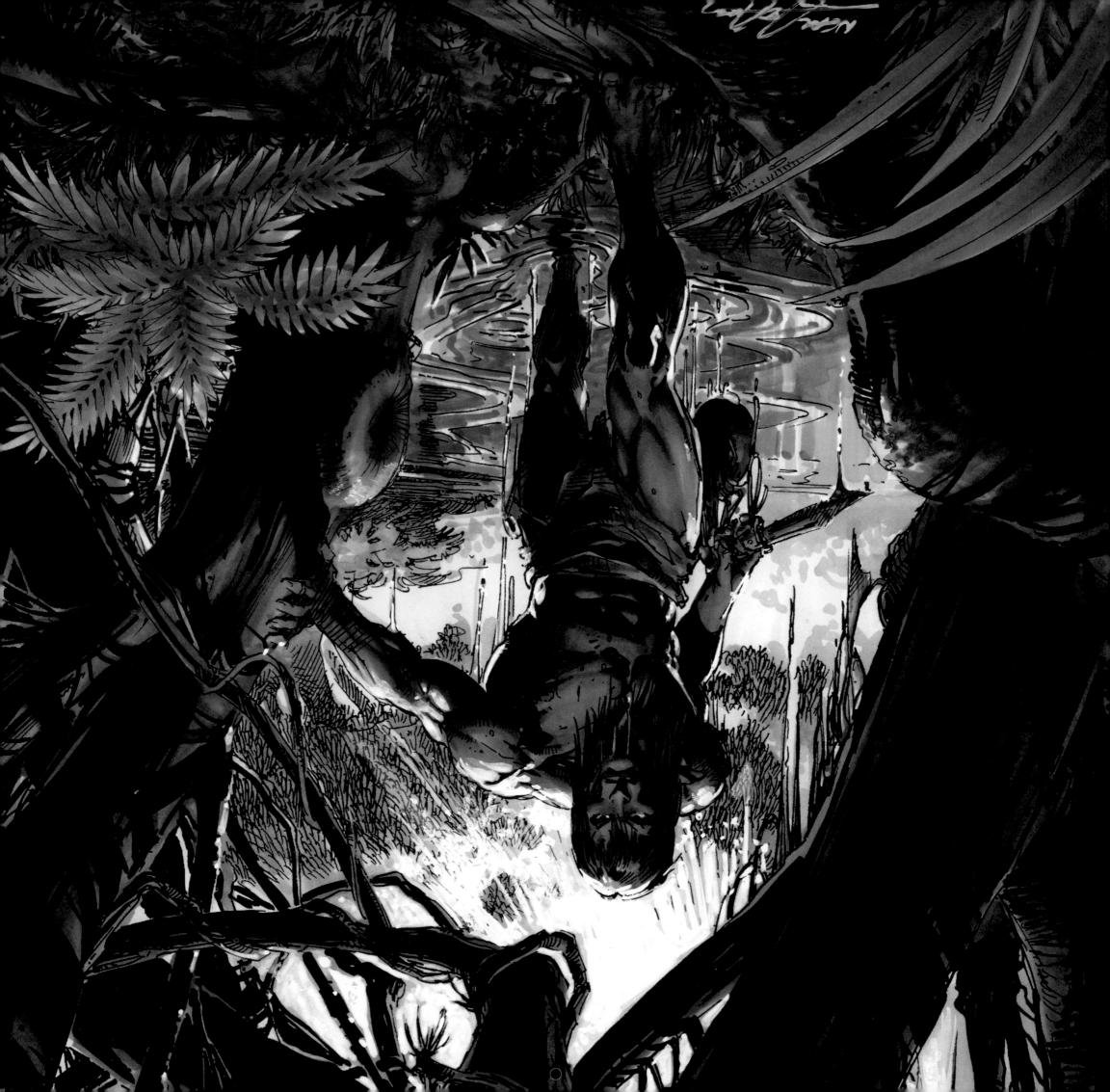

J U N E

SUNDAY	MONDAY	TUESDAY	WEDNESDAY	THURSDAY	FRIDAY	SATURDAY
					1	**2**
3	**4**	**5**	**6**	**7**	**8**	**9**
10	**11**	**12**	**13**	**14**	**15**	**16**
17	**18**	**19**	**20**	**21**	**22**	**23**
24	**25**	**26**	**27**	**28**	**29**	**30**

MAY

	1	2	3	4	5	
6	7	8	9	10	11	12
13	14	15	16	17	18	19
20	21	22	23	24	25	26
27	28	29	30	31		

JULY

1	2	3	4	5	6	7
8	9	10	11	12	13	14
15	16	17	18	19	20	21
22	23	24	25	26	27	28
29	30	31				

NEAL ADAMS (1941) — June 15

FATHERS DAY — June 17

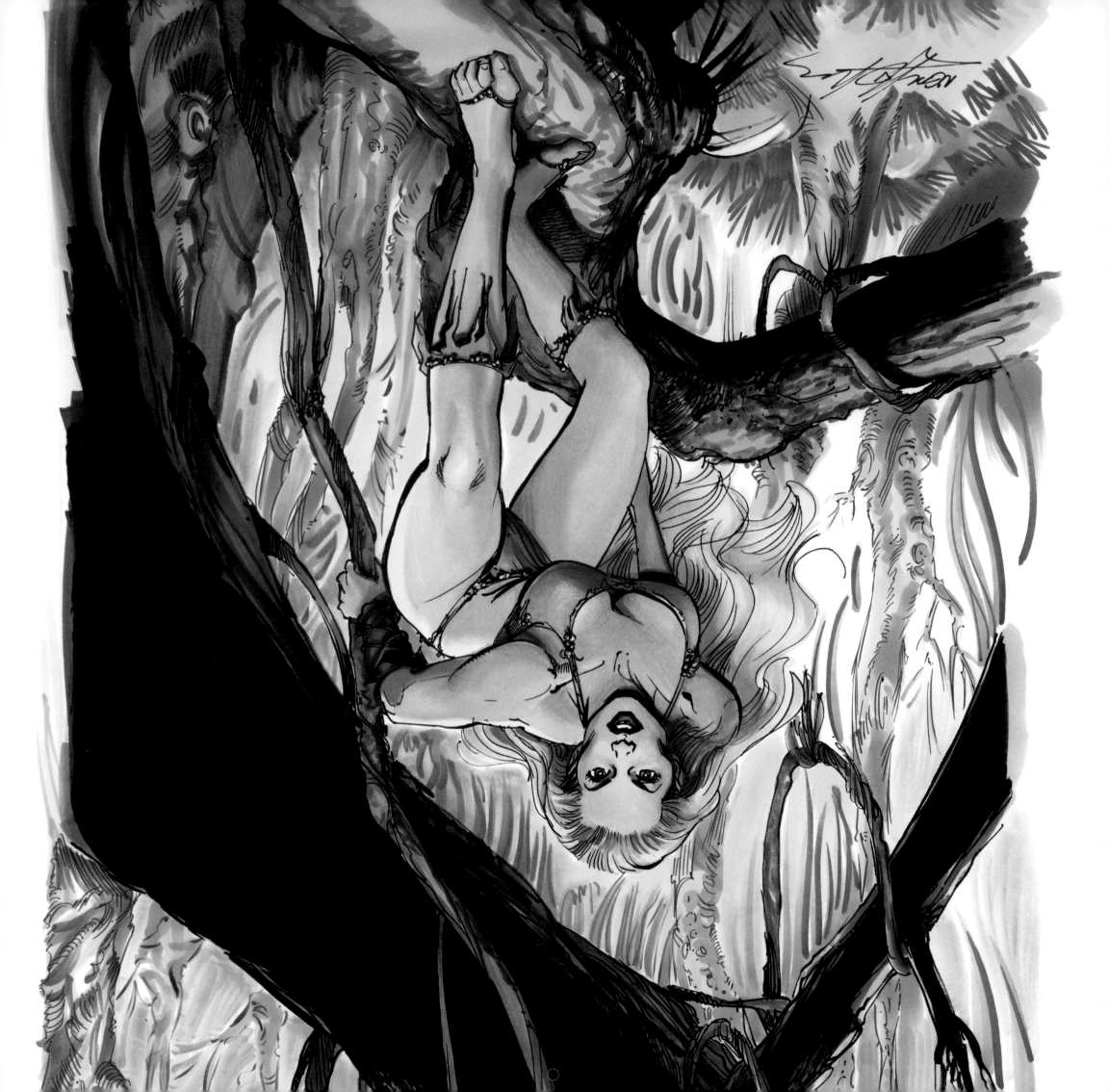

J U L Y

SUNDAY	MONDAY	TUESDAY	WEDNESDAY	THURSDAY	FRIDAY	SATURDAY
1	2	3	4 Independence Day	5	6	7
8	9	10	11	12	13	14 Bastille Day
15	16	17	18	19	20	21
22	23	24	25	26	27	28
29	30	31				

JUNE

					1	2
3	4	5	6	7	8	9
10	11	12	13	14	15	16
17	18	19	20	21	22	23
24	25	26	27	28	29	30

AUGUST

			1	2	3	4
5	6	7	8	9	10	11
12	13	14	15	16	17	18
19	20	21	22	23	24	25
26	27	28	29	30	31	

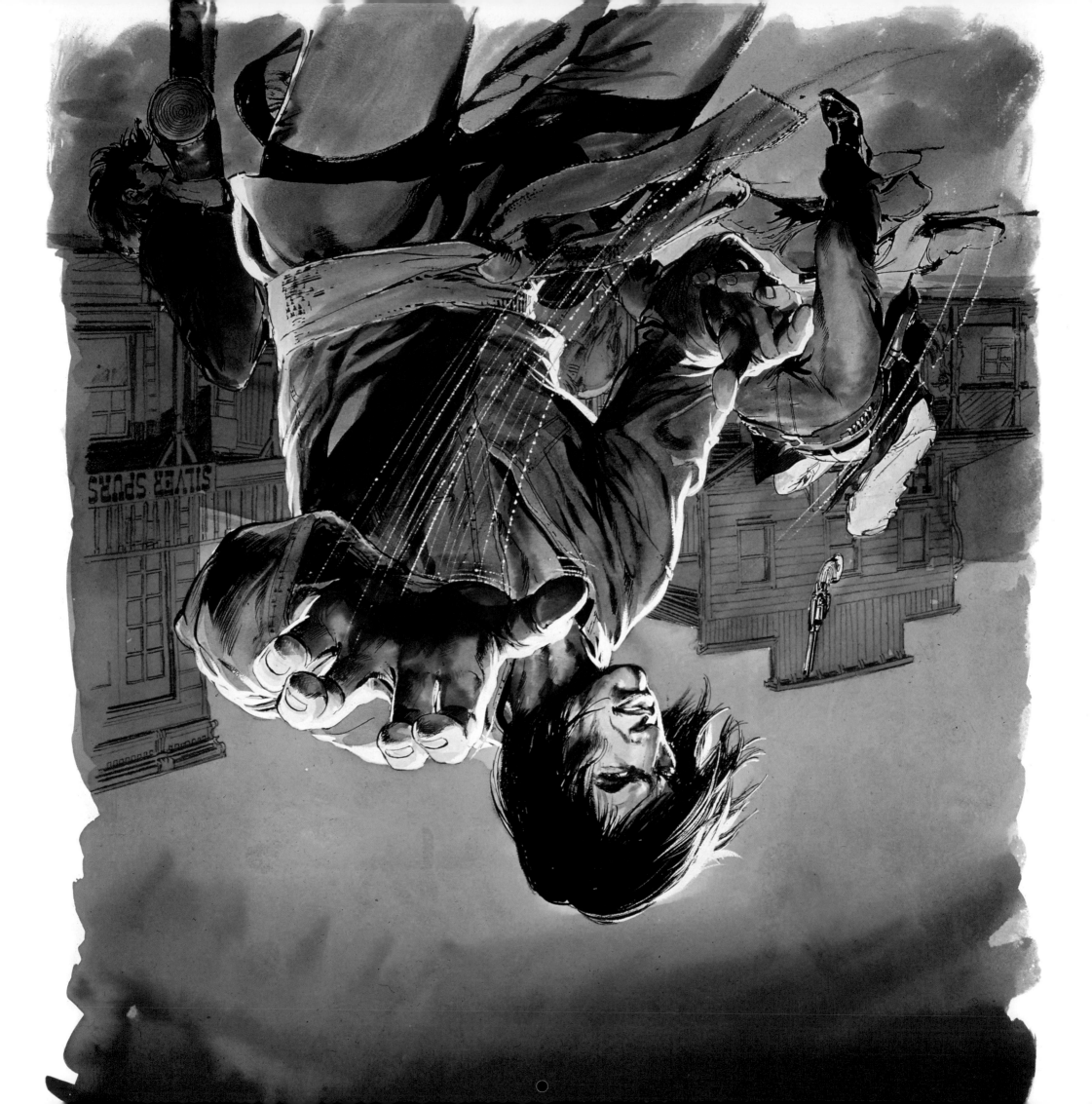

AUGUST

SUNDAY	MONDAY	TUESDAY	WEDNESDAY	THURSDAY	FRIDAY	SATURDAY
	JULY 1 2 3 4 5 6 7 8 9 10 11 12 13 14 15 16 17 18 19 20 21 22 23 24 25 26 27 28 29 30 31		1	2	3	4
5	6	7	8	9	10	11
12	13	14	15	16	17	18
19	20	21	22	23	24	25
26	27	28	29	30	31	

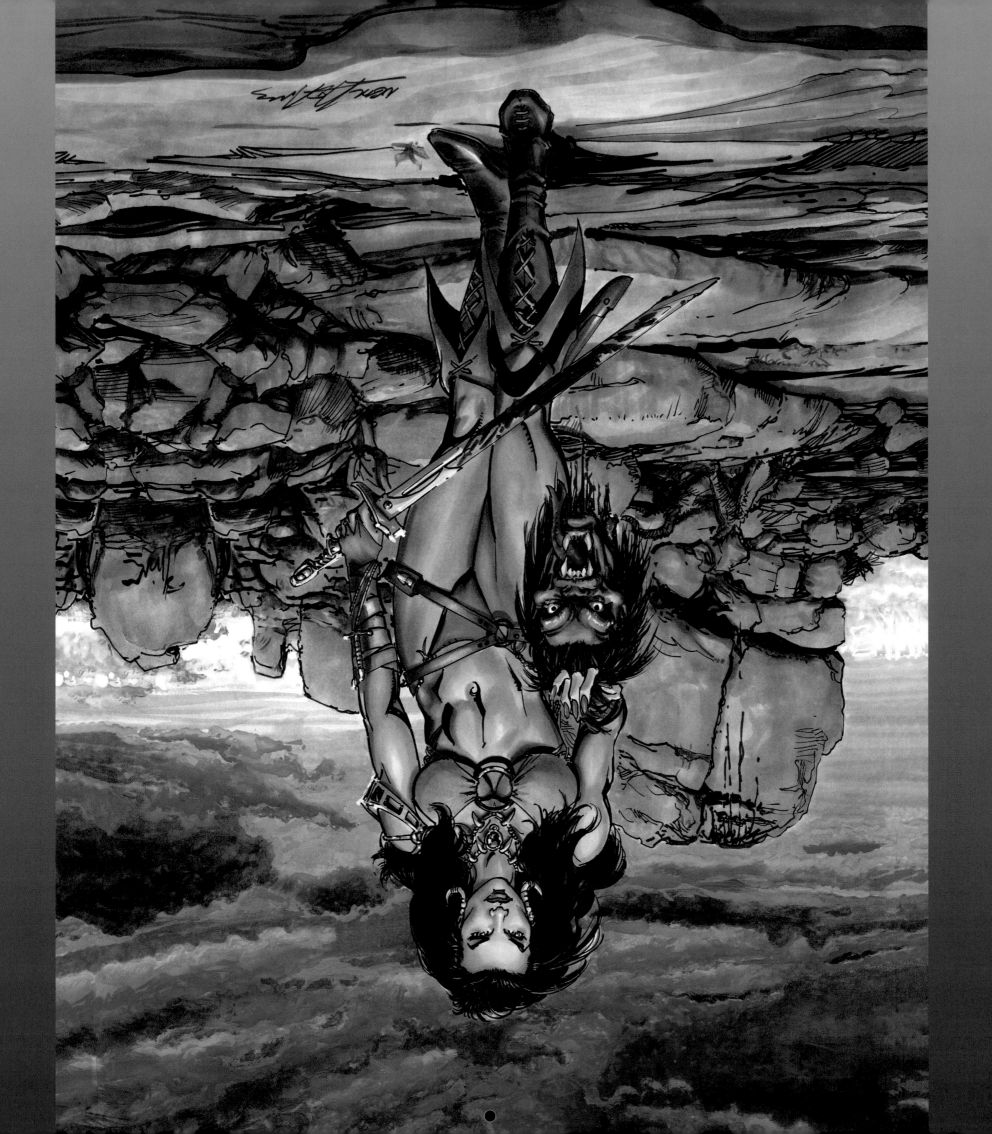

SEPTEMBER

SUNDAY	MONDAY	TUESDAY	WEDNESDAY	THURSDAY	FRIDAY	SATURDAY
						1

AUGUST

		1	2	3	4	
5	6	7	8	9	10	11
12	13	14	15	16	17	18
19	20	21	22	23	24	25
26	27	28	29	30	31	

OCTOBER

	1	2	3	4	5	6
7	8	9	10	11	12	13
14	15	16	17	18	19	20
21	22	23	24	25	26	27
28	29	30	31			

| 2 | 3 Labor Day | 4 | 5 | 6 | 7 | 8 |

| 9 | 10 | 11 | 12 | 13 Rosh Hashanah begins | 14 | 15 |

| 16 | 17 | 18 | 19 | 20 | 21 | 22 Yom Kippur begins |

| 23 | 24 | 25 | 26 | 27 | 28 | 29 |

| 30 | | | | | | |

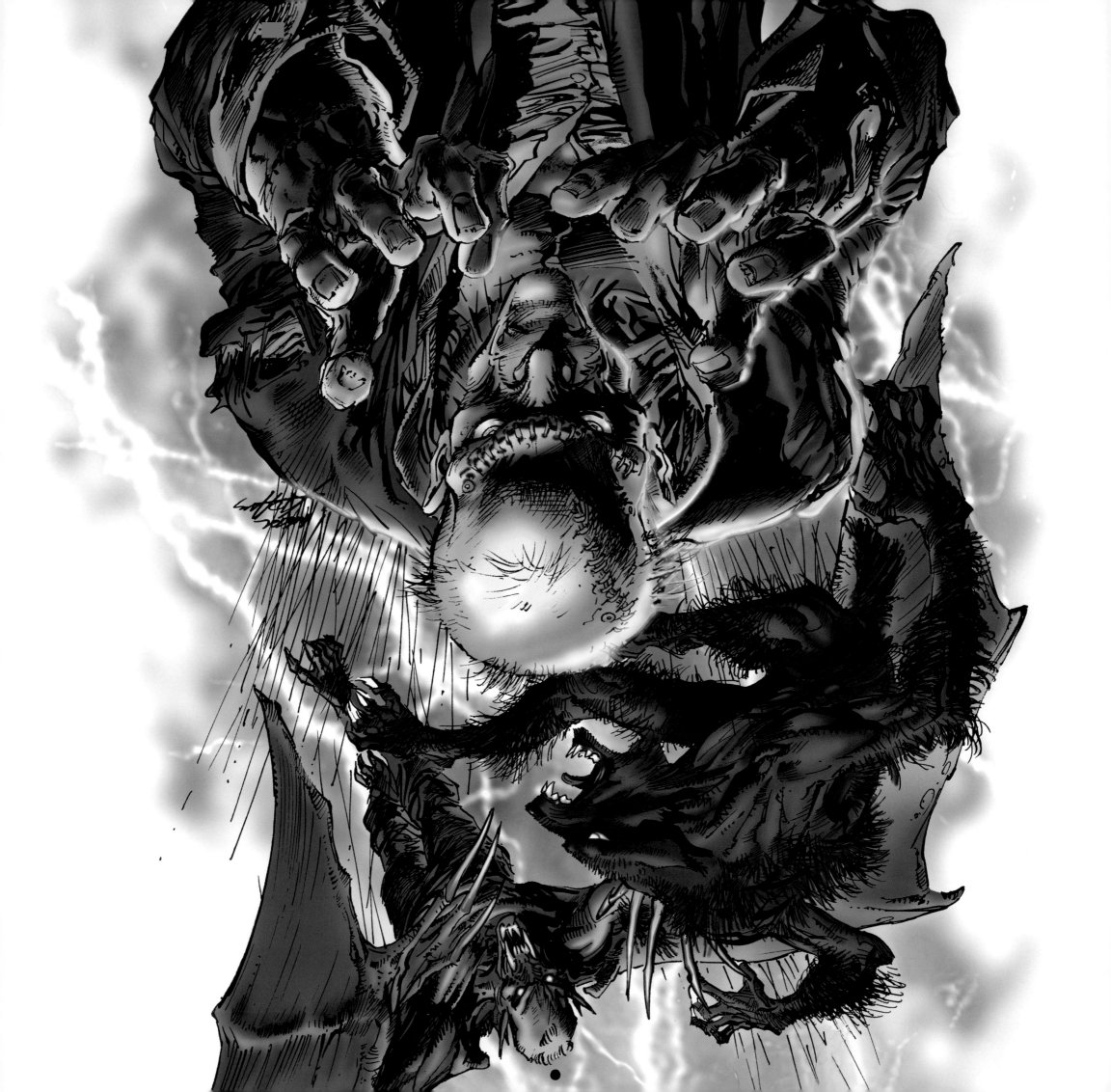

OCTOBER

SUNDAY	MONDAY	TUESDAY	WEDNESDAY	THURSDAY	FRIDAY	SATURDAY
		1	2	3	4	5
6	7	8	9 Columbus Day	10	11	12
13	14	15	16	17	18	19
20	21	22	23	24	25	26
27	28	29	30	31 HALLOWEEN		

NOVEMBER

				1	2	3
4	5	6	7	8	9	10
11	12	13	14	15	16	17
18	19	20	21	22	23	24
25	26	27	28	29	30	

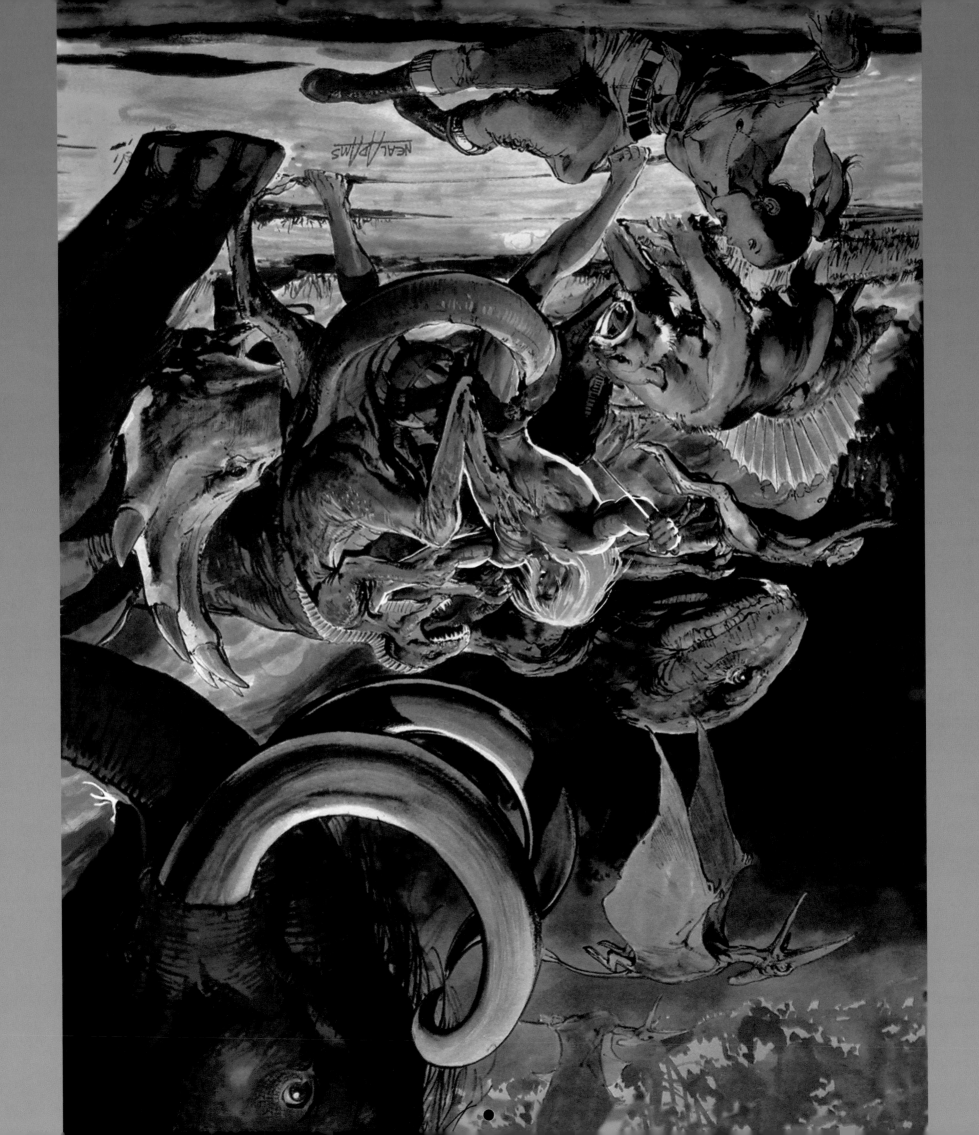

NOVEMBER

SUNDAY	MONDAY	TUESDAY	WEDNESDAY	THURSDAY	FRIDAY	SATURDAY
OCTOBER 1 2 3 4 5 6 7 8 9 10 11 12 13 14 15 16 17 18 19 20 21 22 23 24 25 26 27 28 29 30 31		**DECEMBER** 1 2 3 4 5 6 7 8 9 10 11 12 13 14 15 16 17 18 19 20 21 22 23 24 25 26 27 28 29 30 31		**1**	**2**	**3**
4	**5** GUY FAWKES DAY	**6**	**7**	**8**	**9**	**10**
11 VETERAN'S DAY	**12**	**13**	**14**	**15**	**16**	**17**
18	**19**	**20**	**21**	**22** THANKSGIVING	**23**	**24**
25	**26**	**27**	**28**	**29**	**30**	

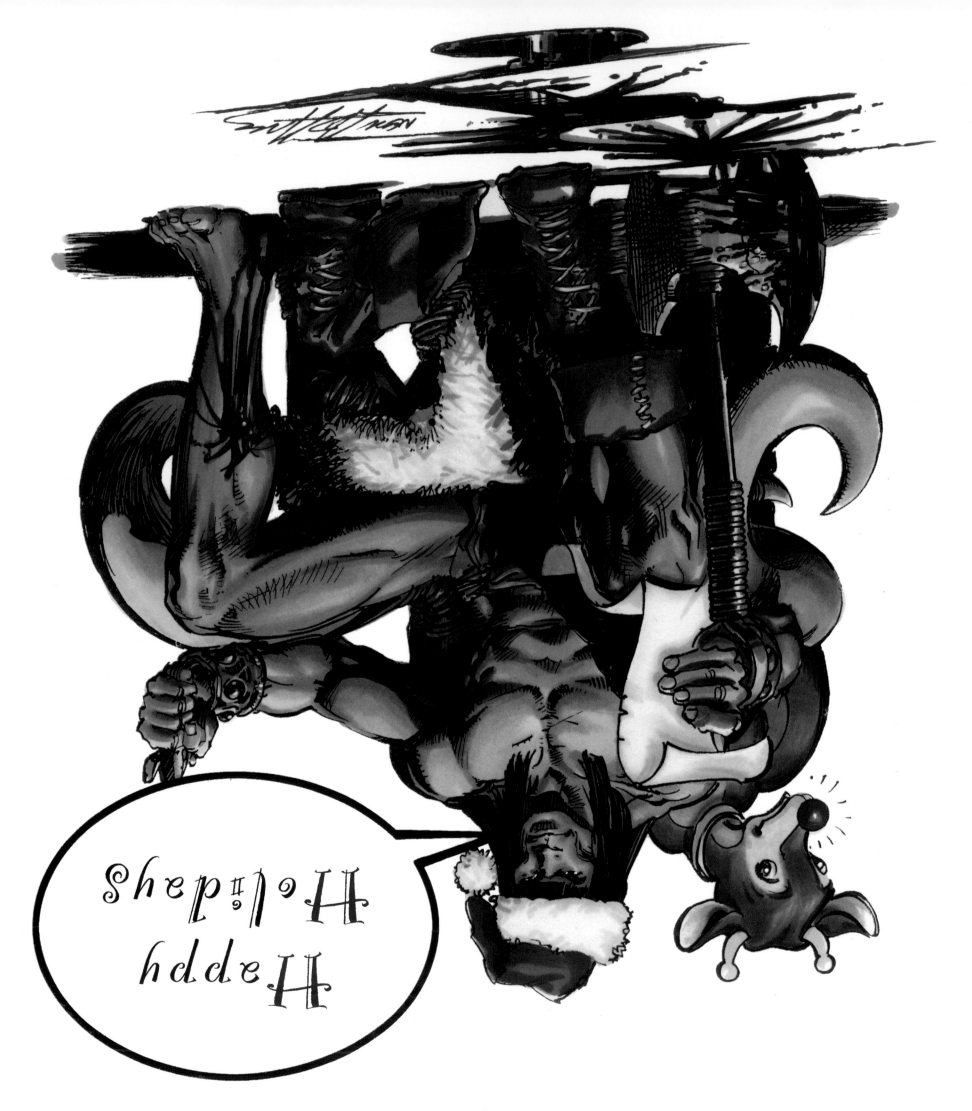

DECEMBER

SUNDAY	MONDAY	TUESDAY	WEDNESDAY	THURSDAY	FRIDAY	SATURDAY
				NOVEMBER 1 2 3 4 5 6 7 8 9 10 11 12 13 14 15 16 17 18 19 20 21 22 23 24 25 26 27 28 29 30		1
2	3	4	5 Hanukkah Begins	6	7	8
9	10	11	12	13	14	15
16	17	18	19	20	21	22
23	24 Christmas Eve	25 Christmas Day	26 Kwanzaa begins	27	28	29
30	31 New Years Eve	**JANUARY** 1 2 3 4 5 6 7 8 9 10 11 12 13 14 15 16 17 18 19 20 21 22 23 24 25 26 27 28 29 30 31				

Neal Adams

Vanguard presents the first-ever calendar devoted to the legendary Batman, X-Men and Tarzan book-cover artist, Neal Adams. Adams' comic-book work serves as a benchmark and inspiration for every illustrator who works in the field to this day. His topflight contributions to Marvel and DC Comics continued steadily through the mid-1970s when the artist felt it the time for expansion. Coinciding with the launch of his Continuity Studios, Adams augmented his comics work with cutting-edge advertising work, theatrical costume & stage design, amusement park ride design, magazine illustration and paperback book covers. Known primarily for his pen & ink work, the artist's legions of fans rarely get to see Adams' paintings. Showcased in this fourteen-month calendar is a unique selection of Neal's seldom-seen fully-rendered, color works. Some, are being published here for the first time anywhere.

ISBN 1-887591-98-2

51295>

9 781887 591980